# A Chorus Of Canines

Laura Garabedian

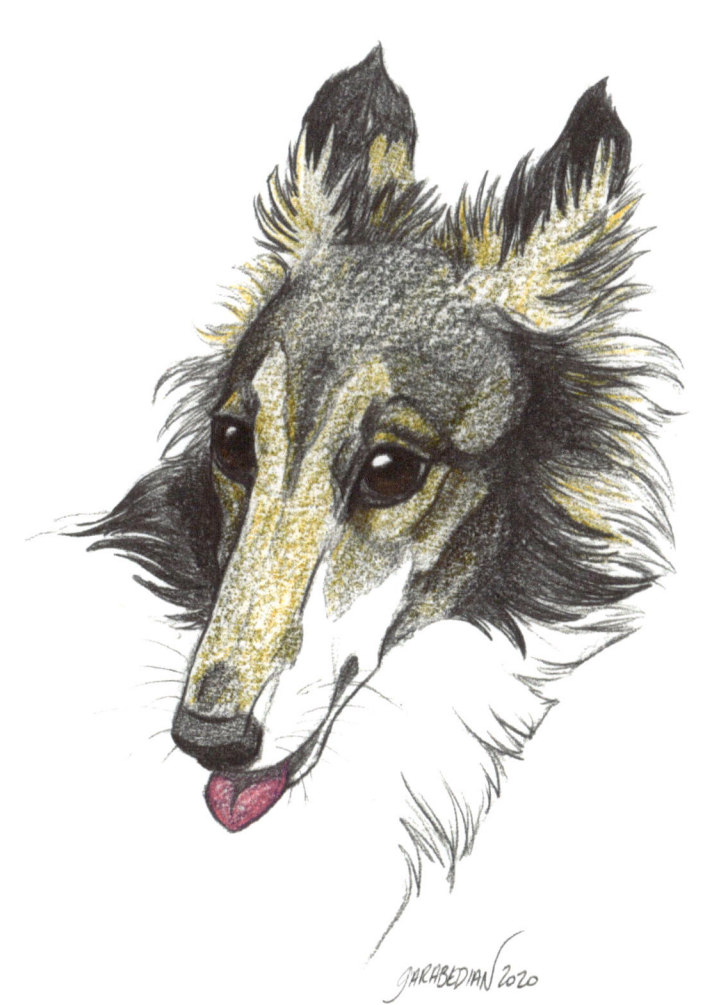

Copyright © 2021 Laura Garabedian

Published by Argyll Productions
ISBN 978-1-61450-532-7

All rights reserved. This book or any portion thereof may not be reproduced or used in any manner whatsoever without the express written permission of the author.

First Printing, 2021

www.FairyTalesWithTails.com

This book is dedicated to Cathi Wester, Janell Casey DVM, Megan Lundberg, Nicola Conchie, and the rest of my Silken Windhound family. You've changed my life in so many ways.

Thank you.

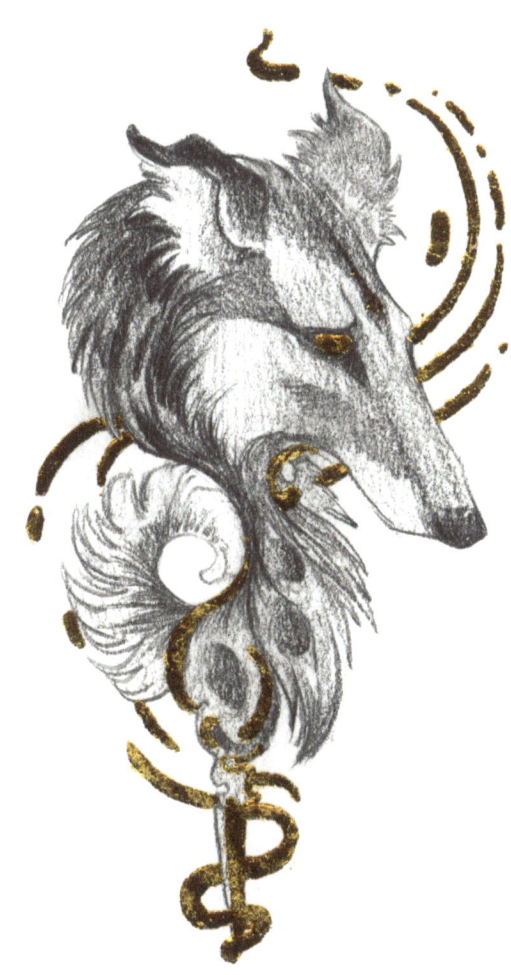

# Introduction

This book is a celebration of my love of dogs, especially of sighthounds. I grew up surrounded by animals, but never particularly considered myself a 'dog person' until I added my first Silken Windhound to our home. The Silken Windhound community in Colorado is incredibly welcoming and our household quickly became one that regularly attended dog events. I made friends with marvelous people who continue to support and inspire me.

Sighthounds are evocative subjects to draw. Their lean forms are a lovely juxtaposition of hard lines and soft curves, attenuated limbs, and their huge eyes and wonderful expressions just beg to be painted.

I hope you enjoy getting to know the dogs in this book.

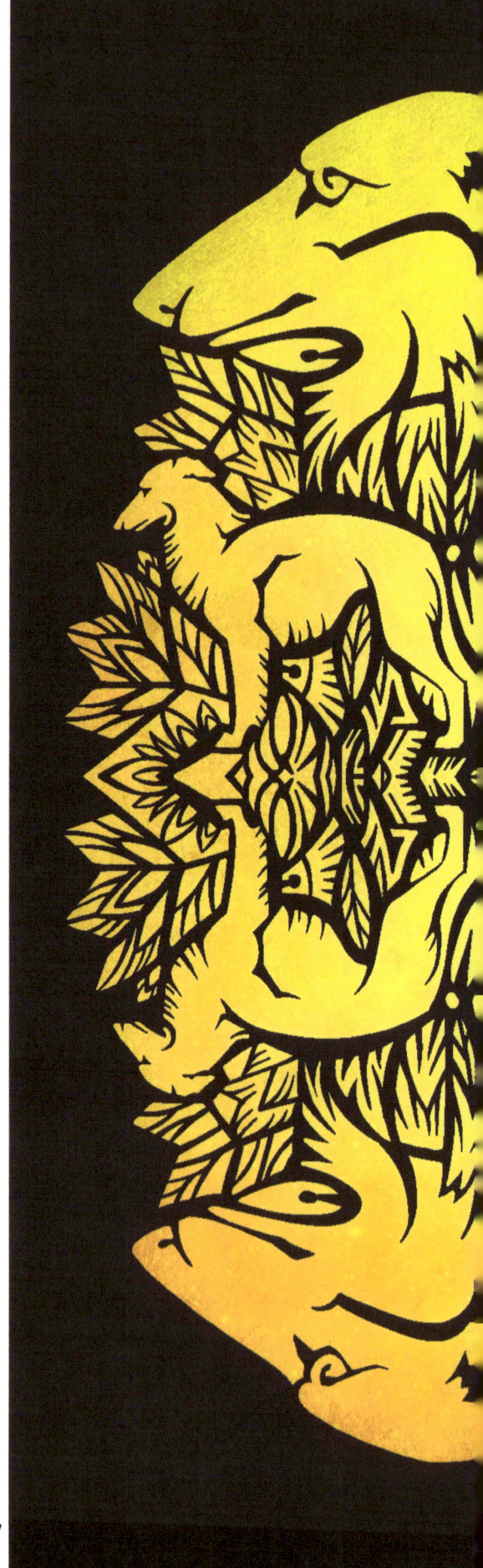

"Golden Silken Mandala"

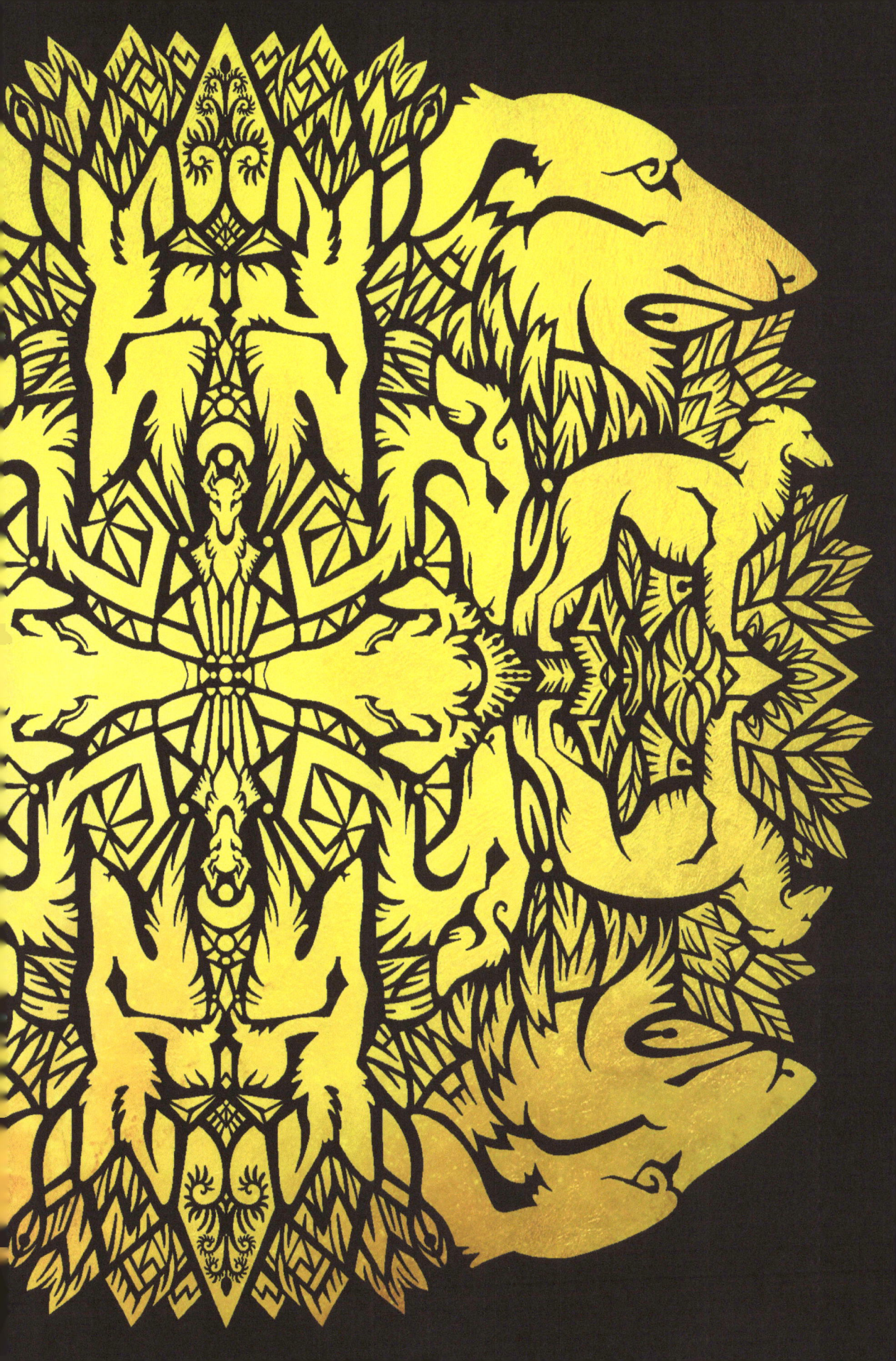

# The Saints

Inspiration can come from strange and silly moments, like finishing up dance practice and throwing your headscarf on your ever patient hound.

Baku just watched me with his sweet soft eyes as I took this picture (right). He reminded me so much of the iconography I grew up with in the Greek Orthodox Church that my brain immediately made the jump from 'well, if dogs were saints…' to 'well, if dogs had saints…'.

The series that followed has proven to be one of my more popular, as well as being incredibly enjoyable to paint and experiment with. All of the original pieces in this series feature metallic watercolor pigments which just gleam and shimmer in person.

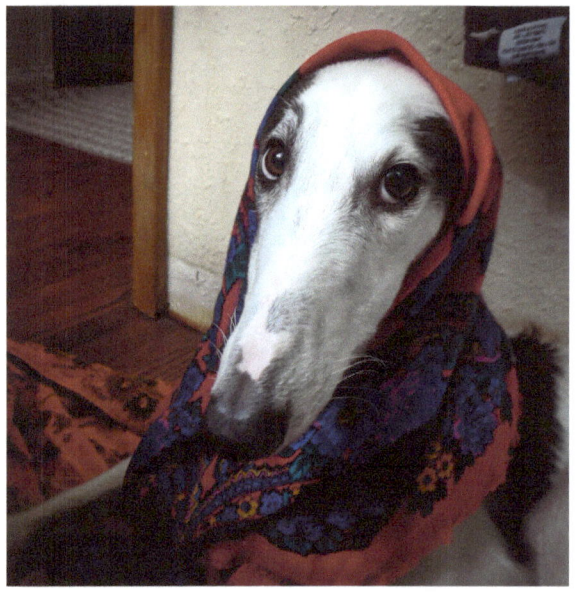

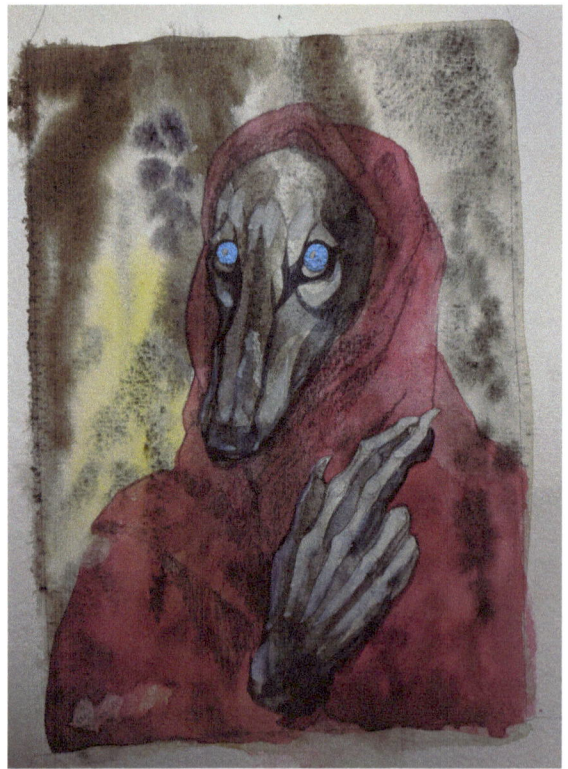

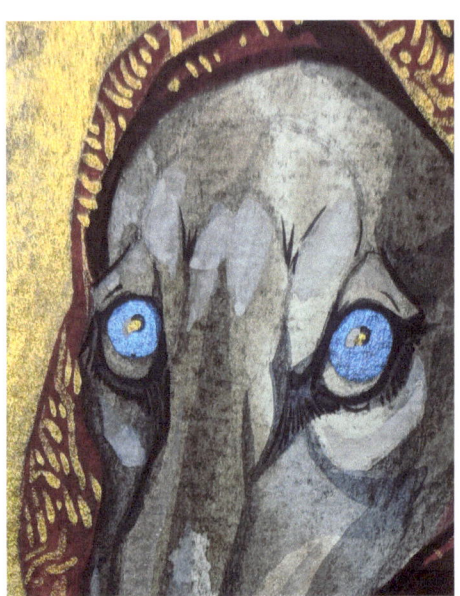

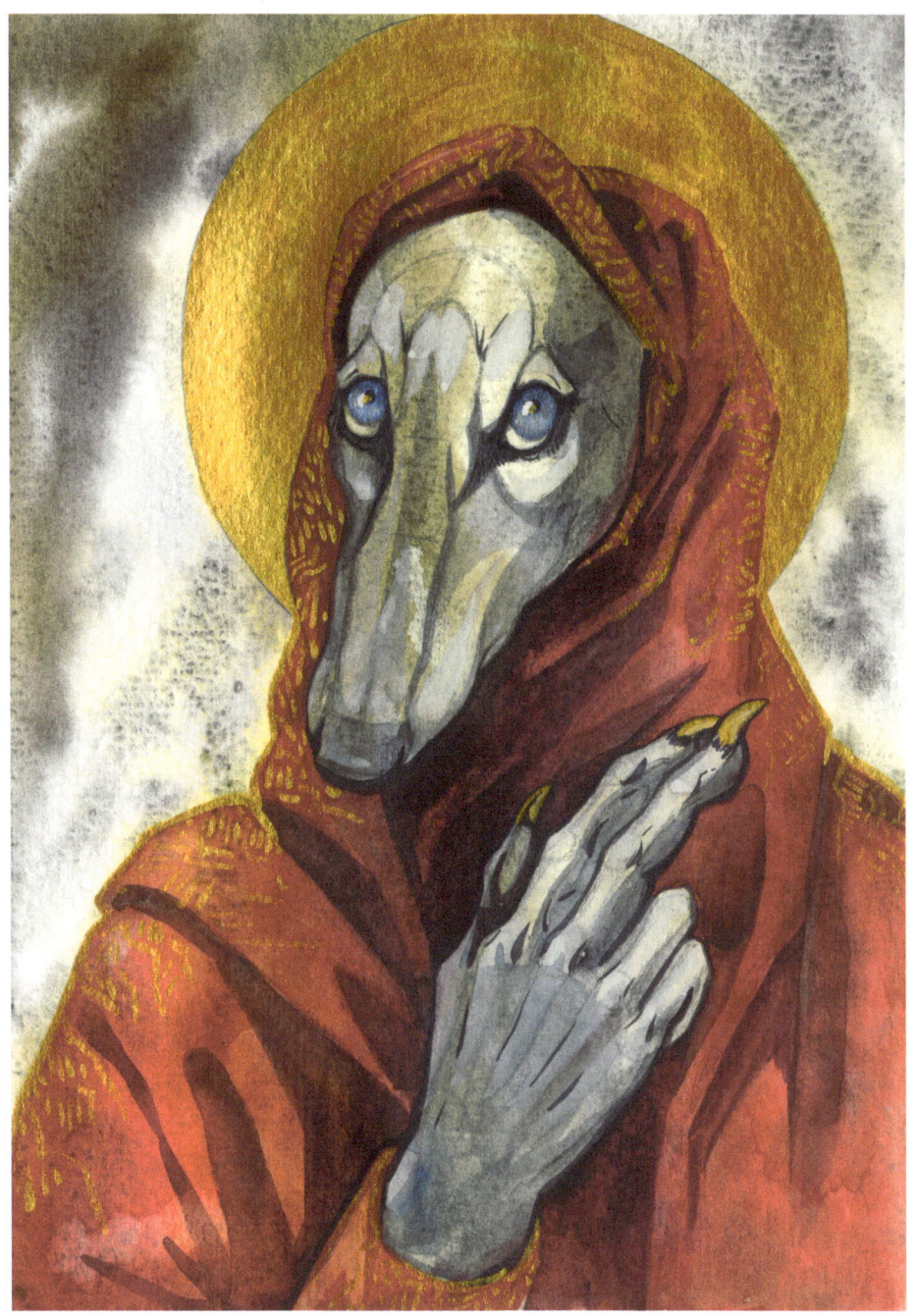

"Silken Saint"

The saints started here, with this Silken Windhound saint based on my angelic dog Baku. He is my eater-of-nightmares, my personal exercise coach, my un-judging confidant, and he is certainly deserving of his sainthood.

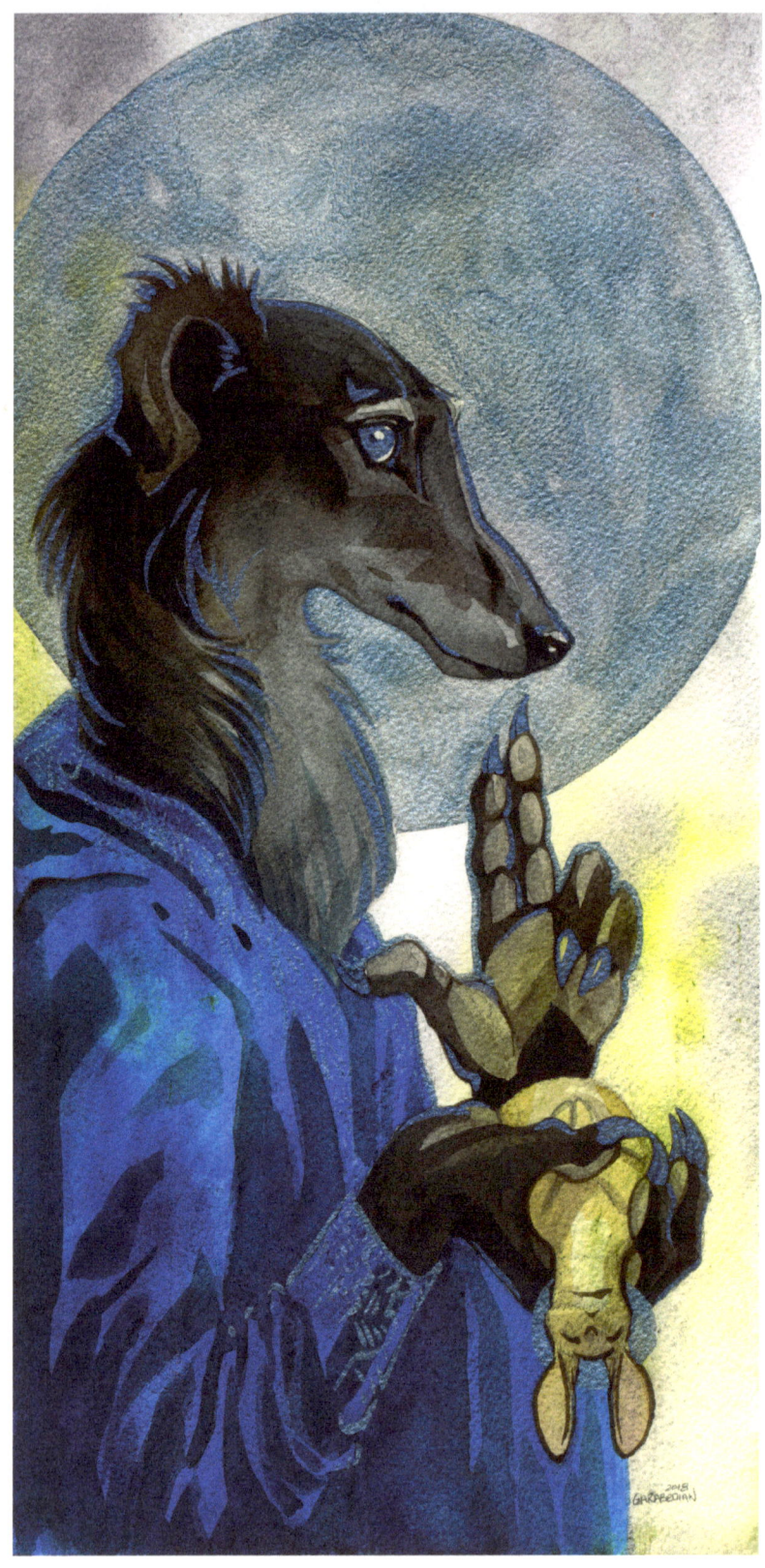

"Our Lady of the Bunnies"

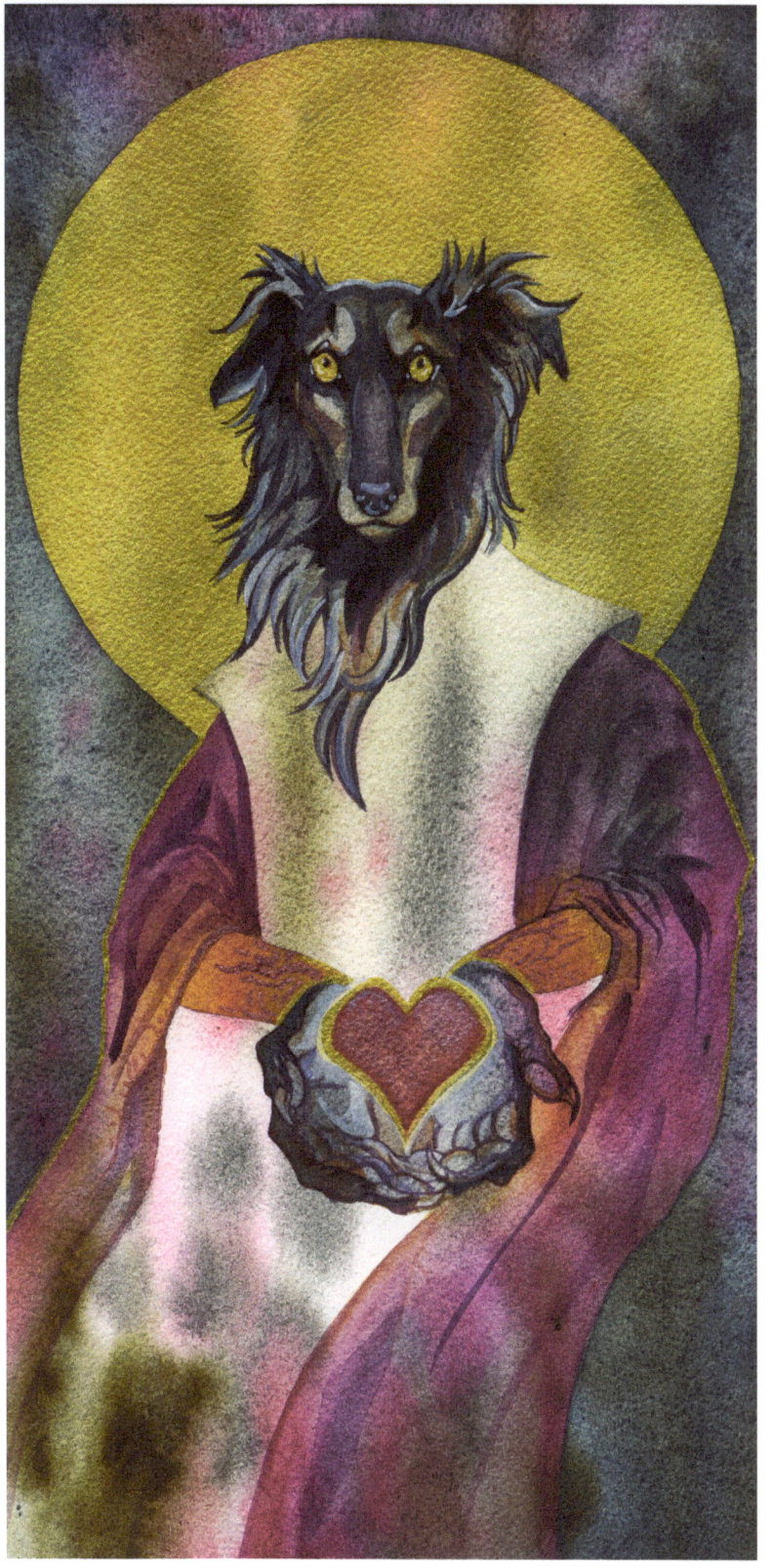

"Silken of the Heart"

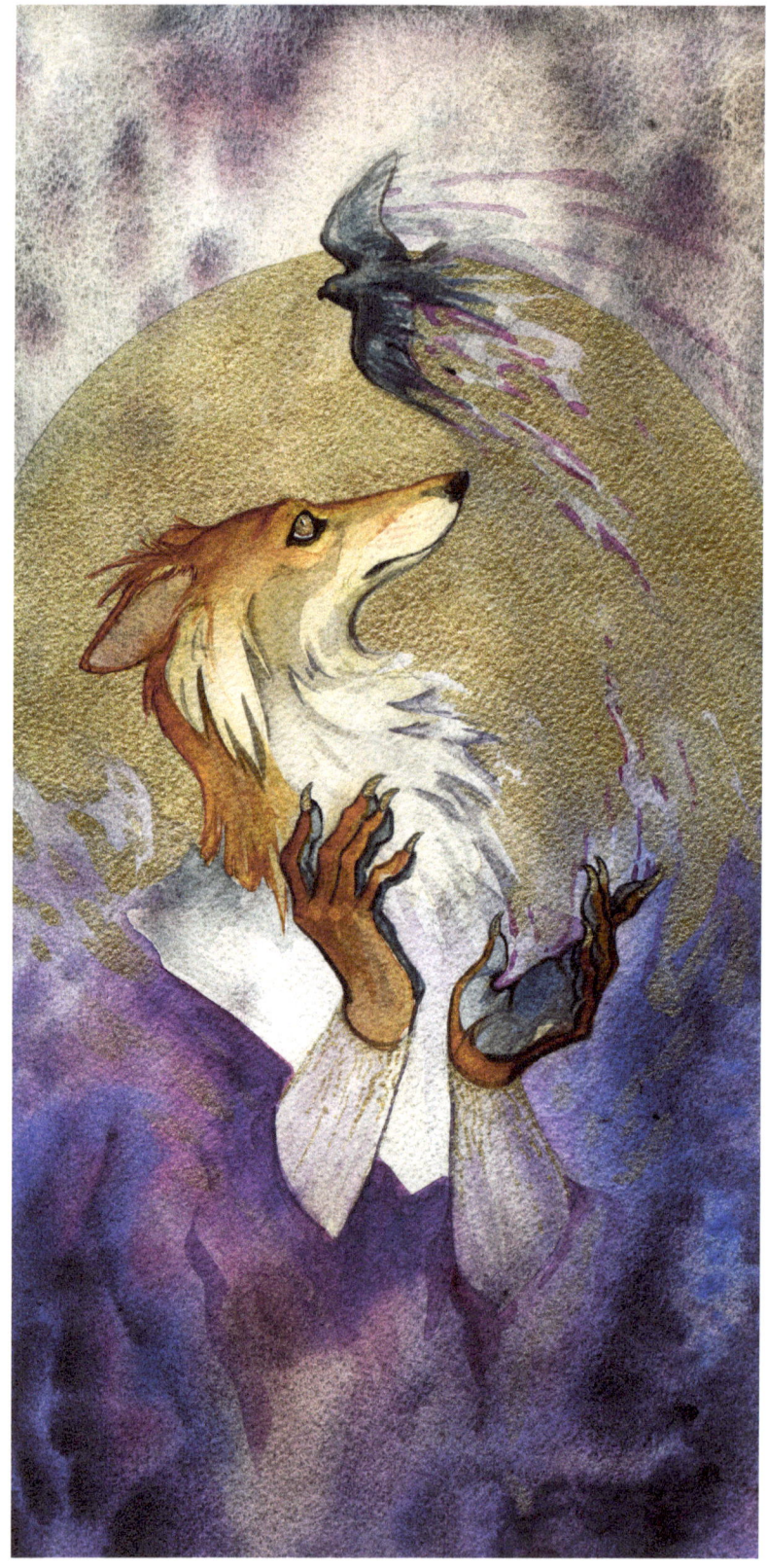

"Saint of Flight"

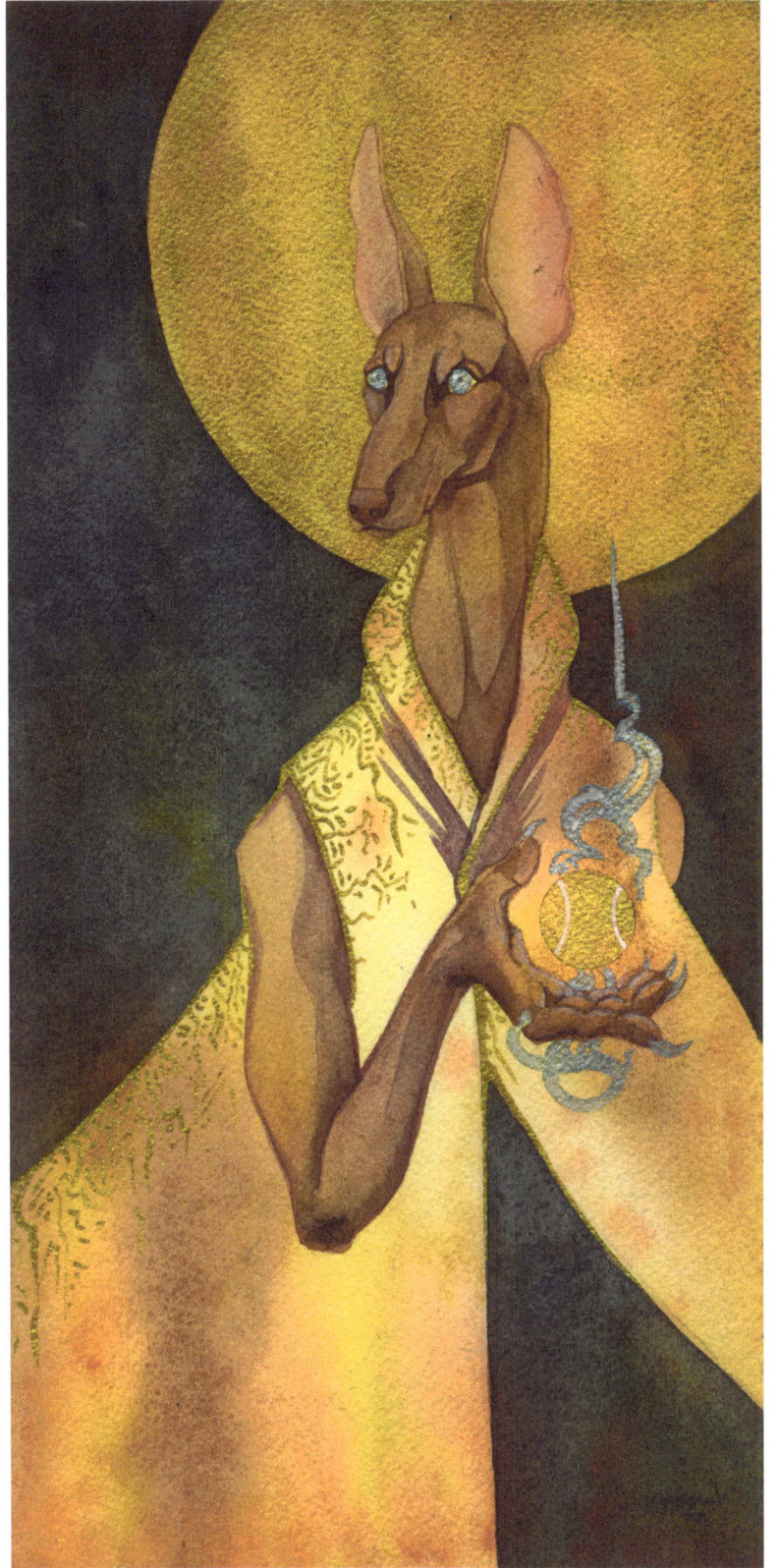

"The Golden Sphere"

# Sacrament of Bone

"Sacrament of Bone" is one of my favorite pieces. It epitomizes the journey of my saints, combining the soulful look in the dog's eyes with the carefully rendered fur while the organic flow of the watercolors contrast nicely with strong geometric shapes.

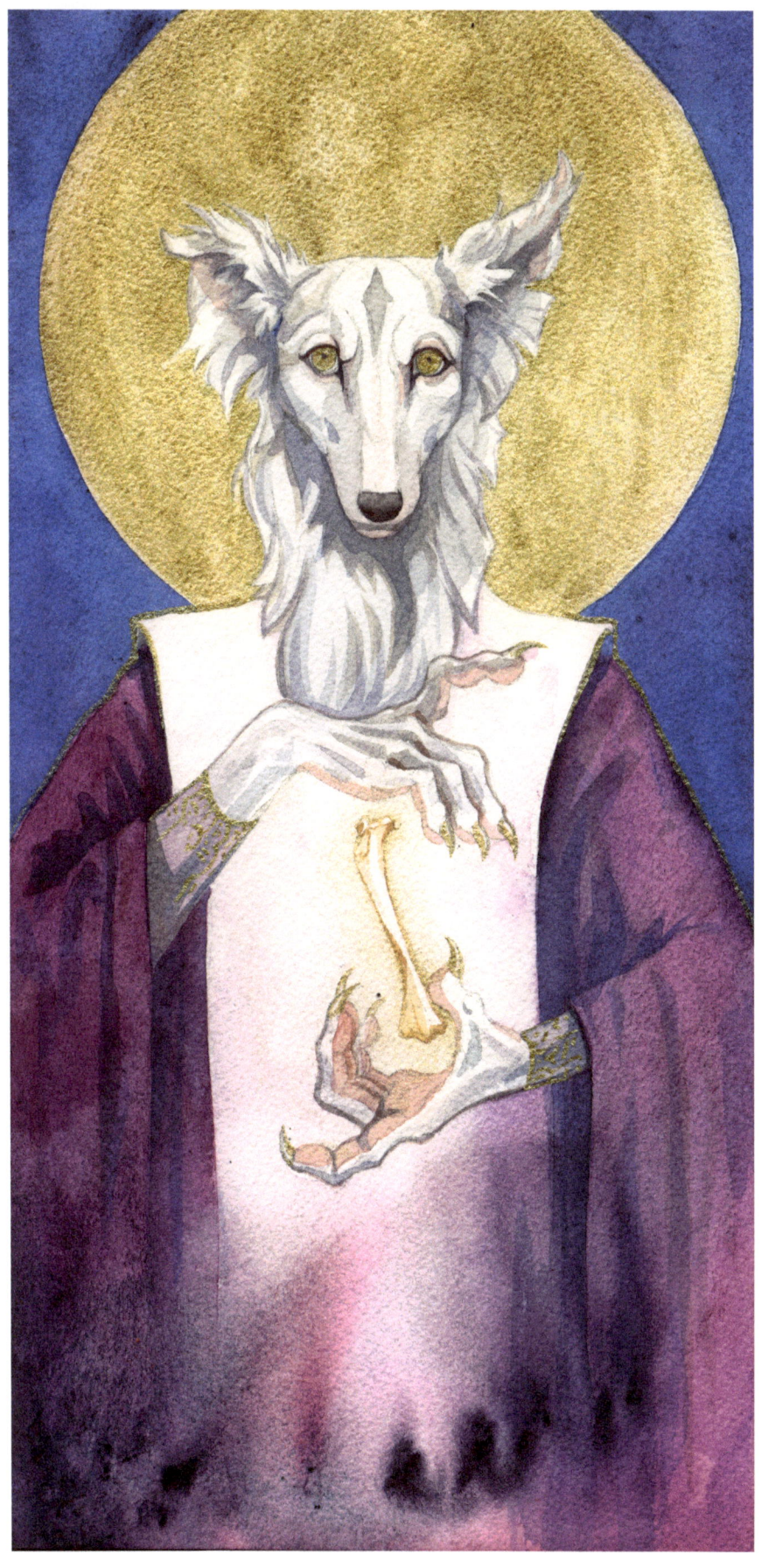

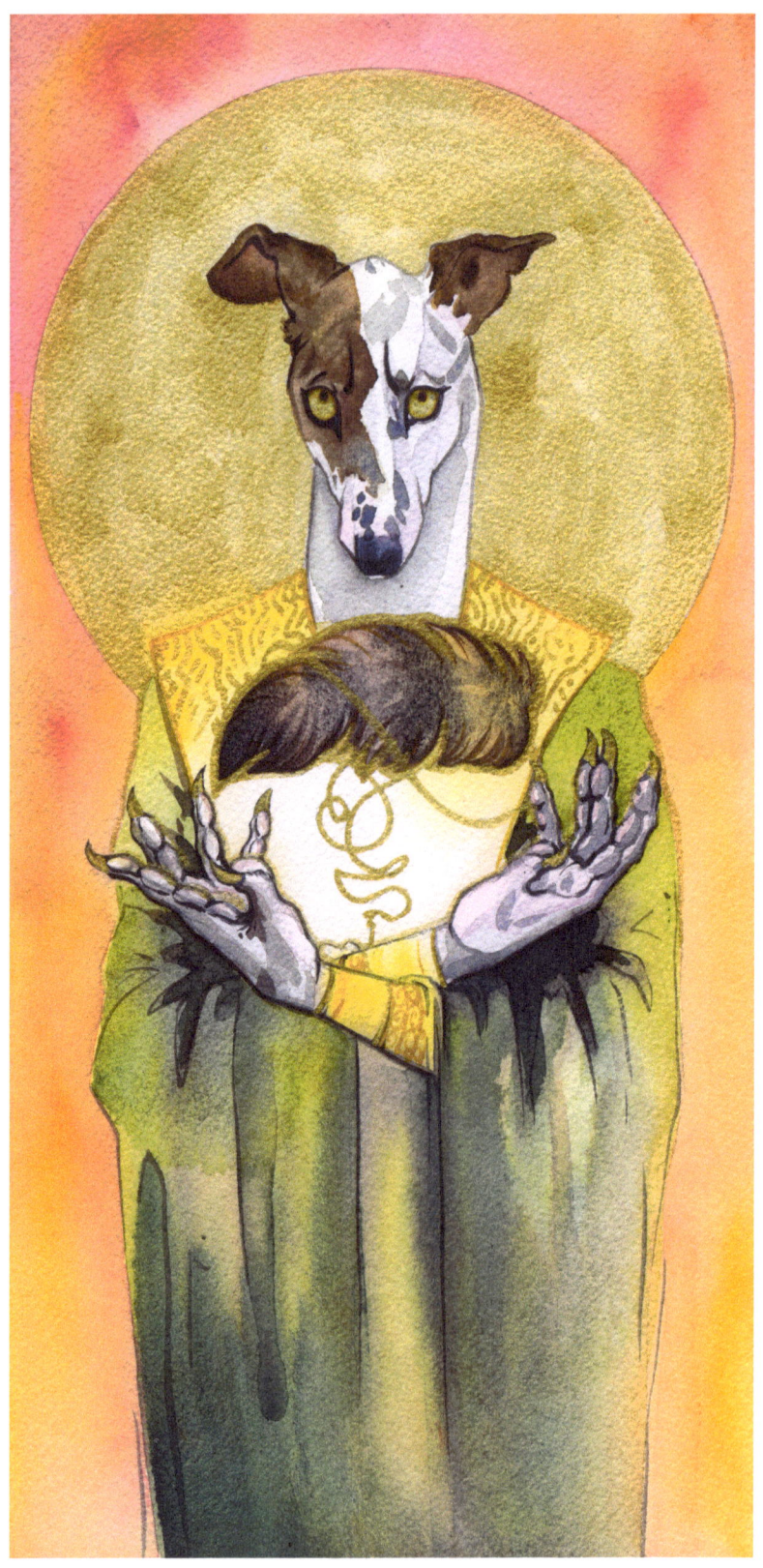

"Lord of the Lure"

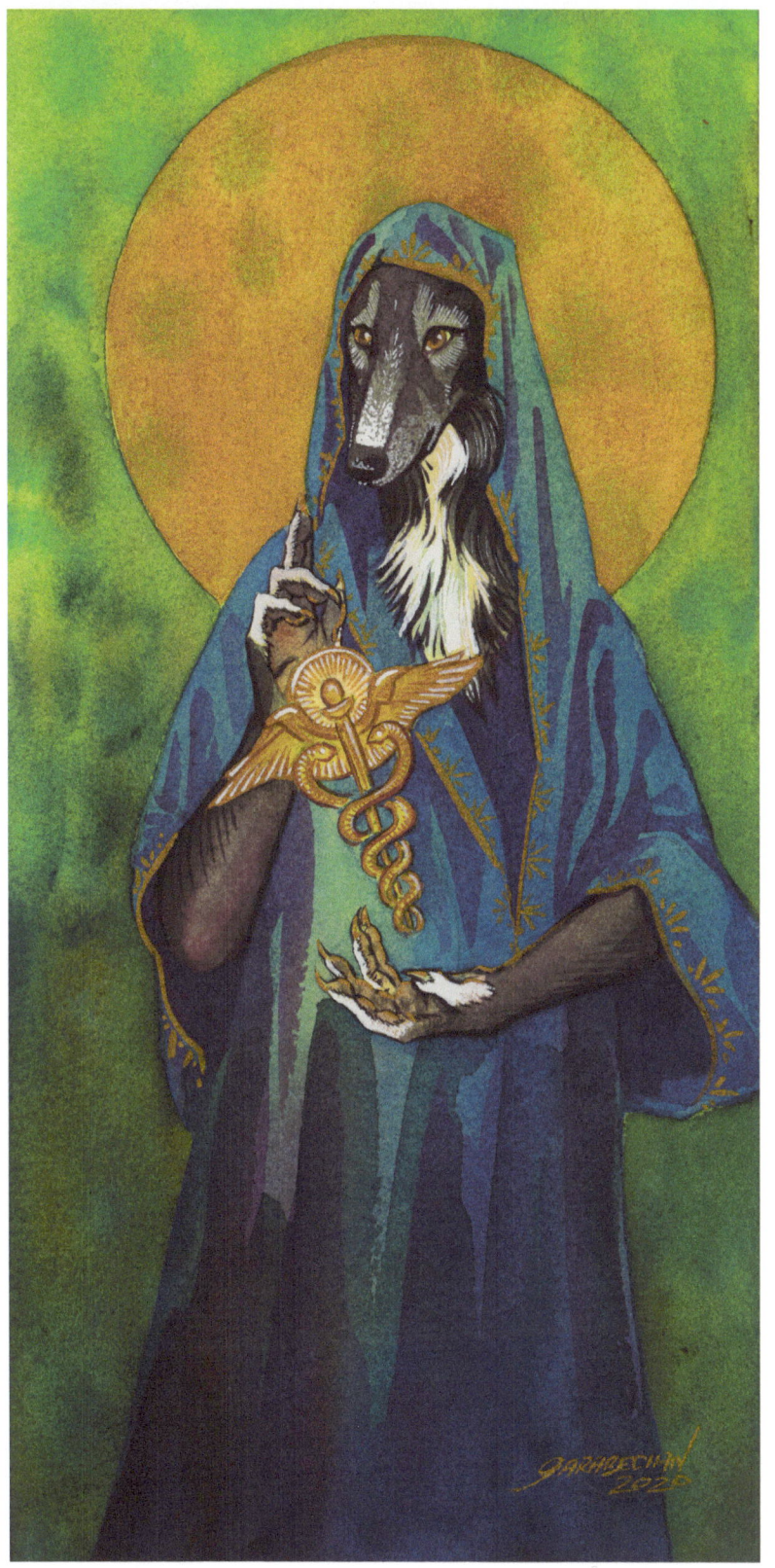

"Sanctus Sanitatum"

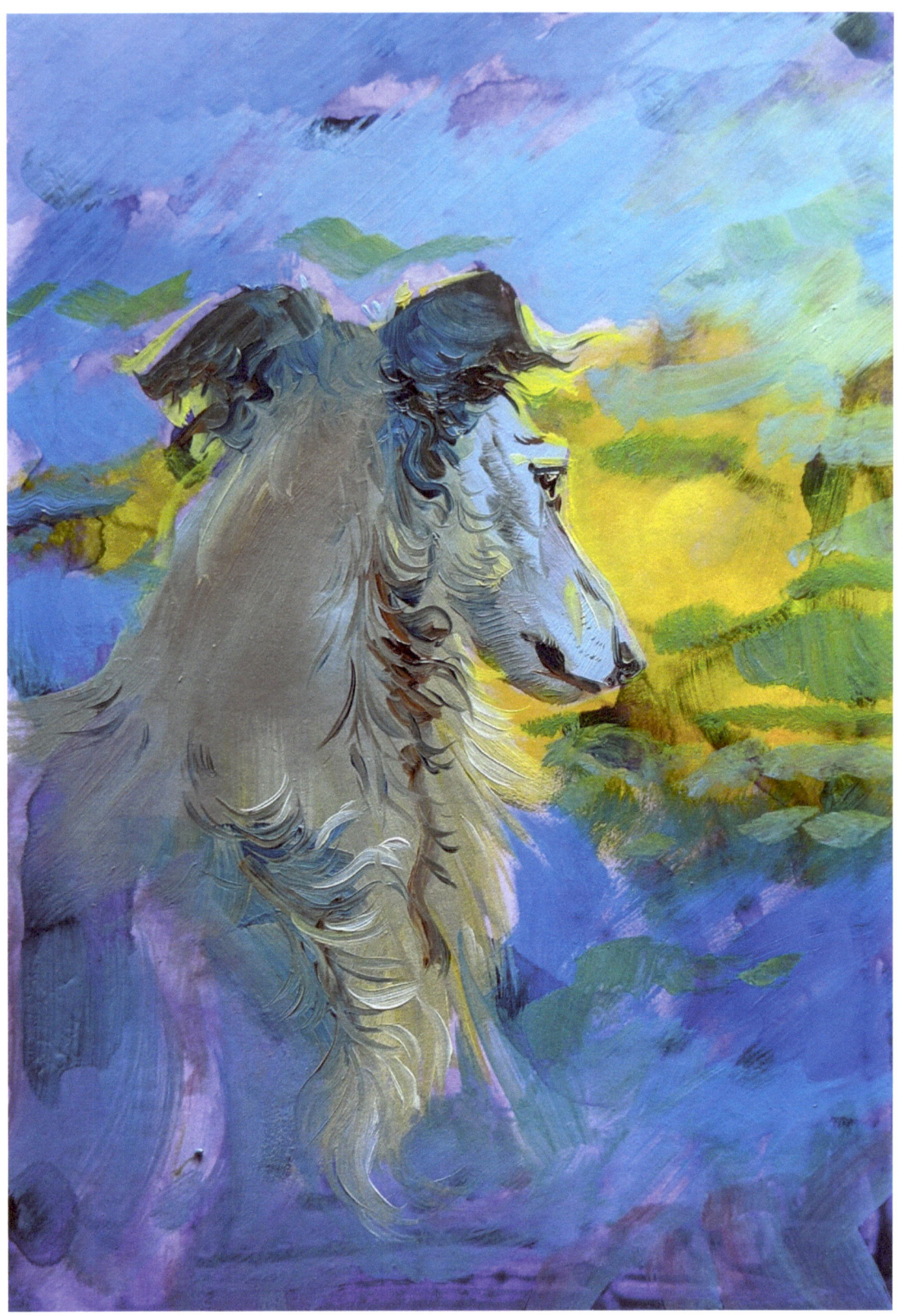

"A Stormy Silken Silhouette"

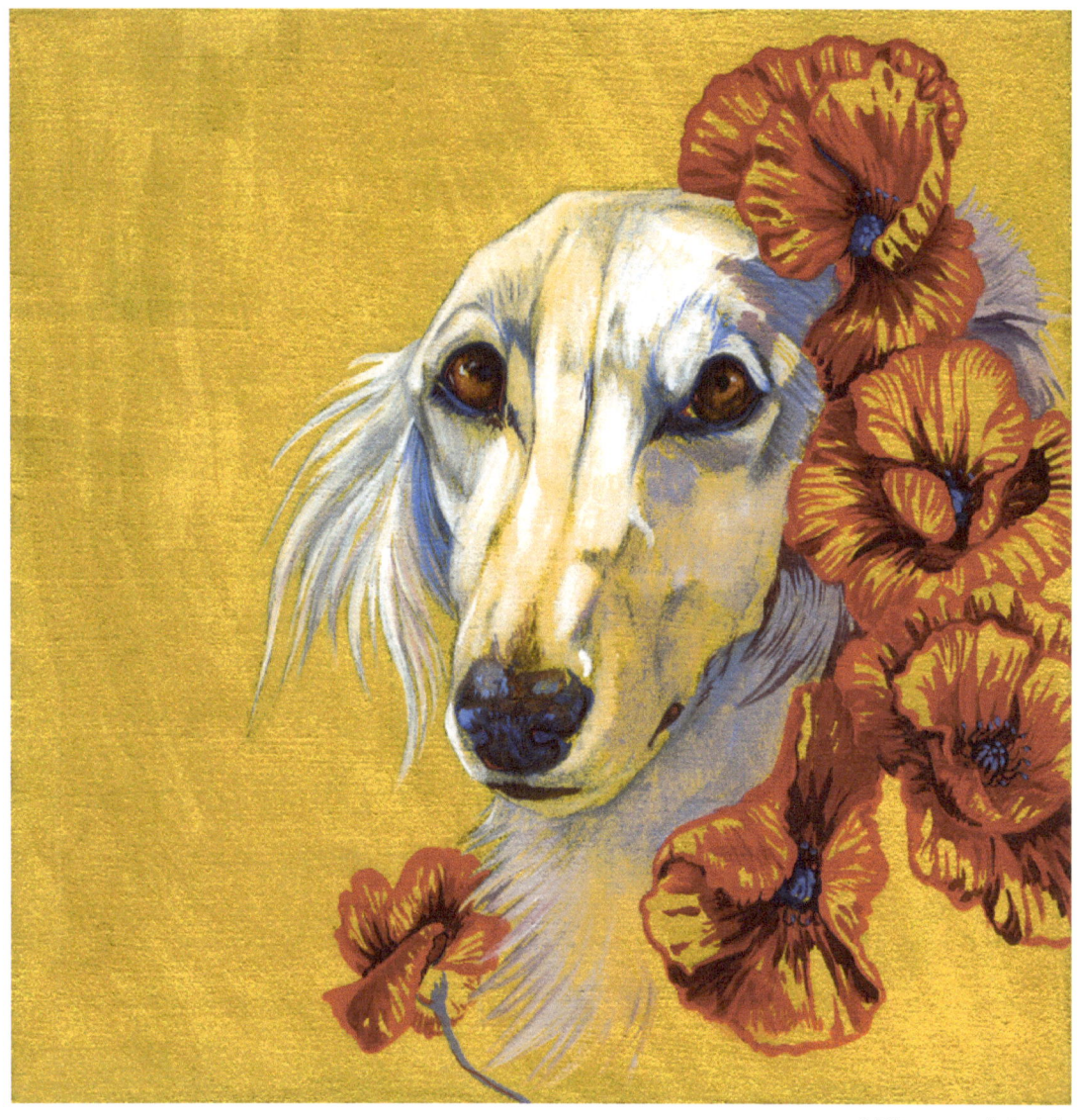

"Silver and Gold"

# Portraits in Oils

Comparably simpler in concept than many of my other works, these paintings have much more to do with the ephemeral nature of catching the sympathetic gaze or the regal silhouette of Silken Windhounds. There is such nobility in the lines of sighthounds. I will never tire of watching them.

# Art in the Wild

There is something incredibly fulfilling about turning a two dimensional design into something that can be worn, be it a pin, a shirt, a tote bag or a scarf. I love hearing about the ways people display my art-turned-accessories.

Making enamel pins has been particularly satisfying. I've done at least one—and often two—new designs per year for the past four years. They have primarily featured Silken Windhounds.

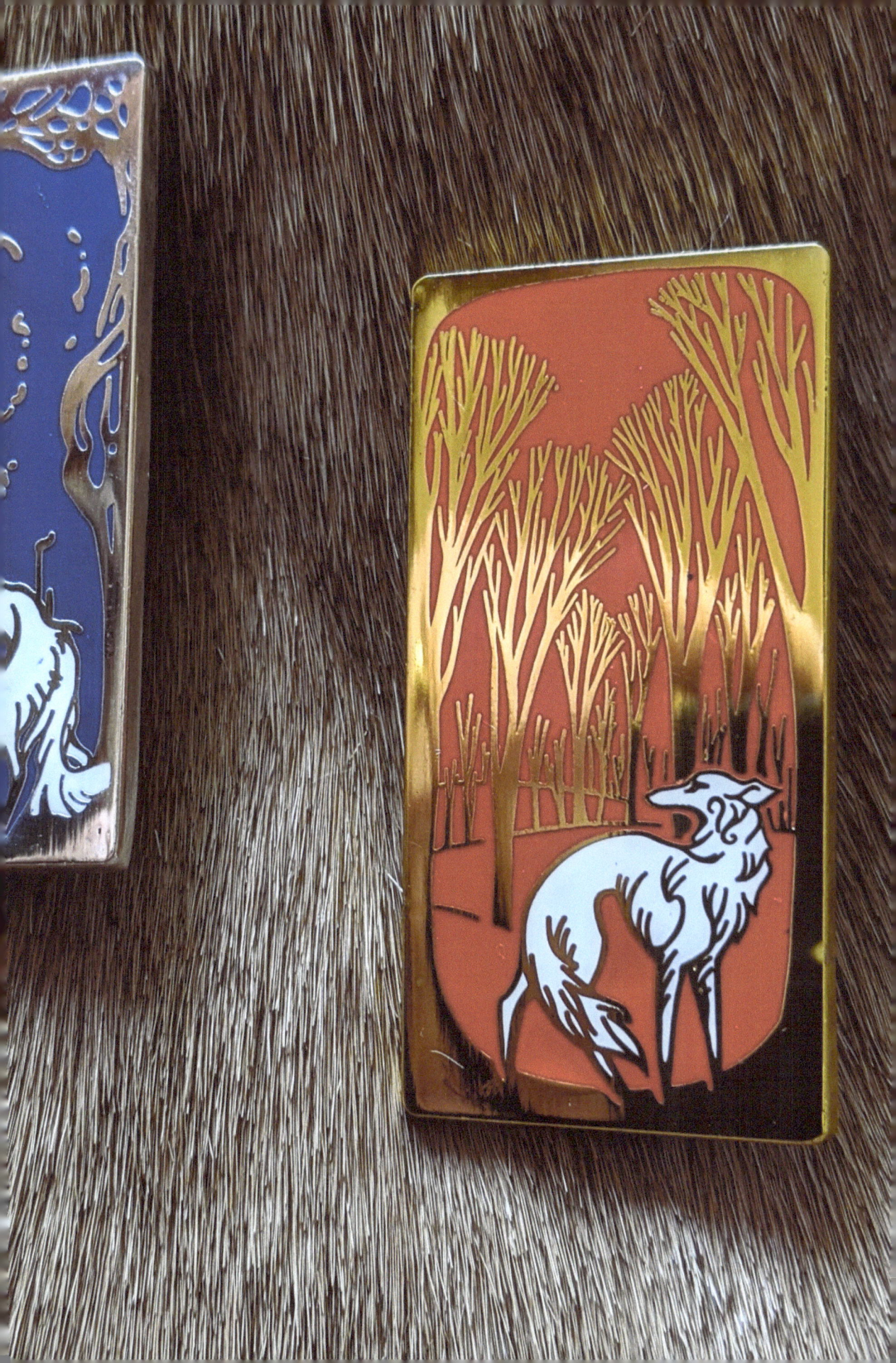

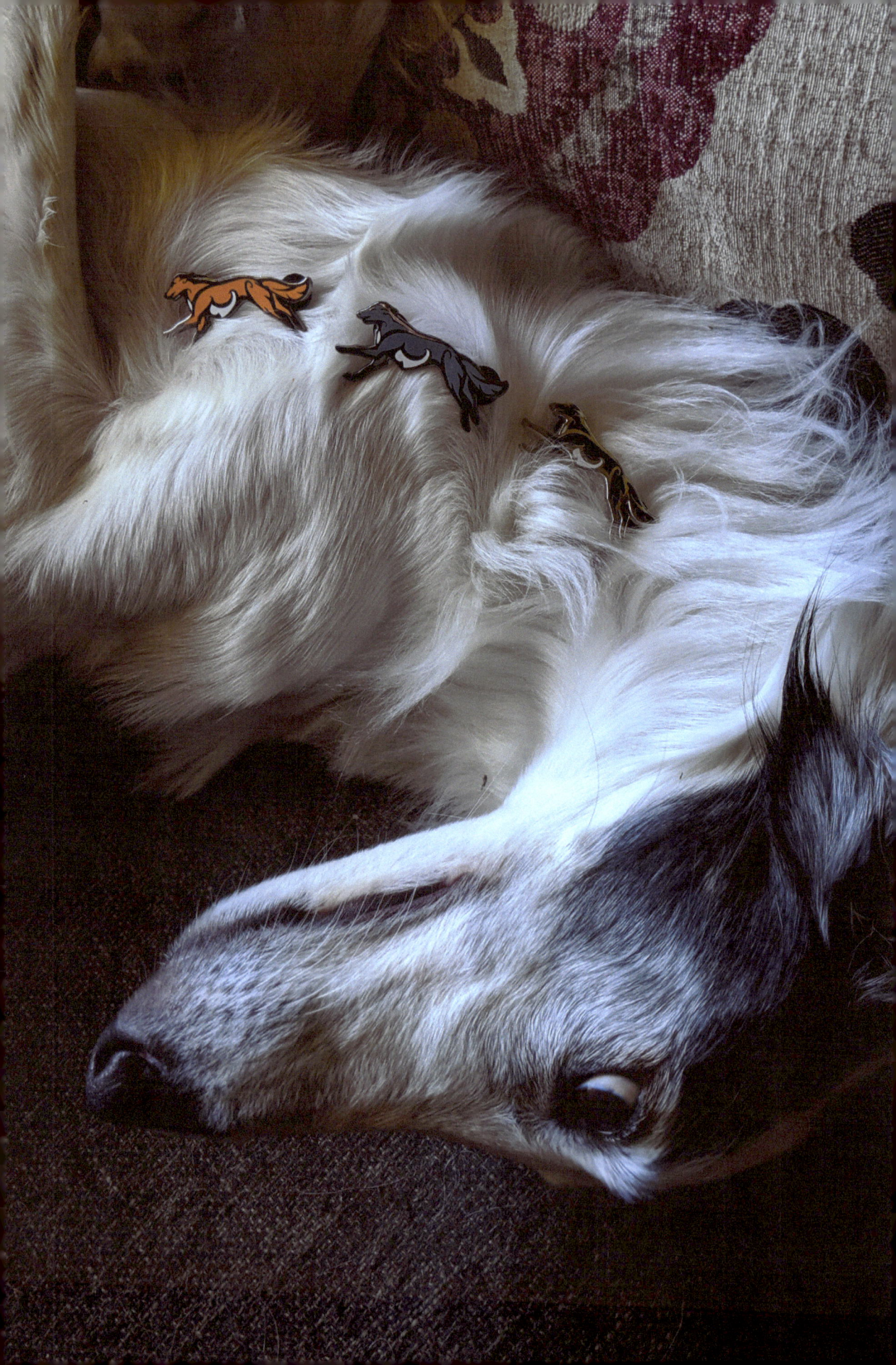

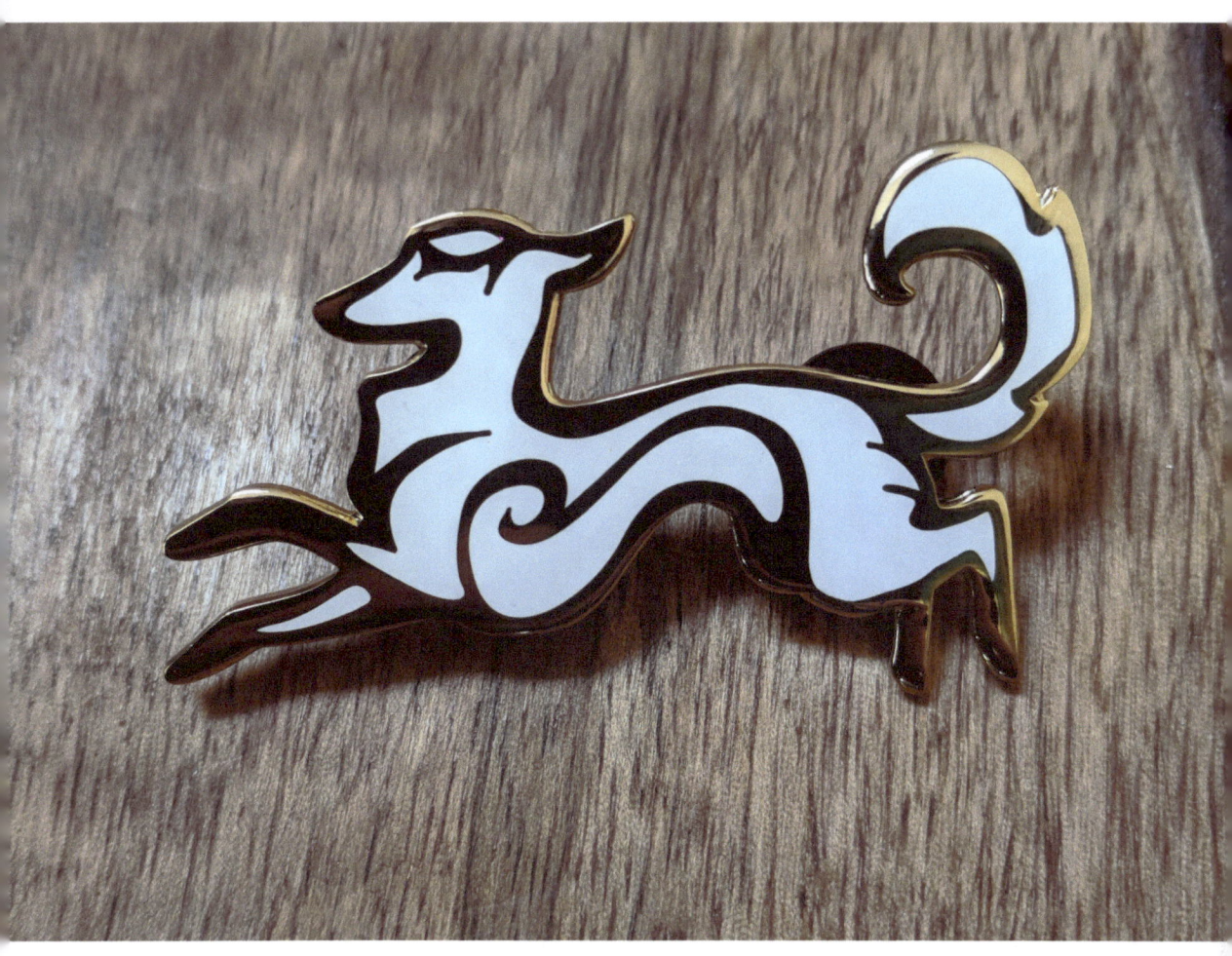

# Silkens in Motion

The "Dancing Silken" (above) was my first foray into the popular hard enamel pins that I was seeing around. I received a great deal of support for this piece, a limited edition of 100, and fell in love with designing pins.

The "Zoom Silken" pins presented by my stellar model Baku (left) were made the following year and solidified my enjoyment of the pin making process. They are still a well-loved design and I had fun creating a piece that translated well into a few colors for a rainbow of Windhounds.

# Mythic Silkens

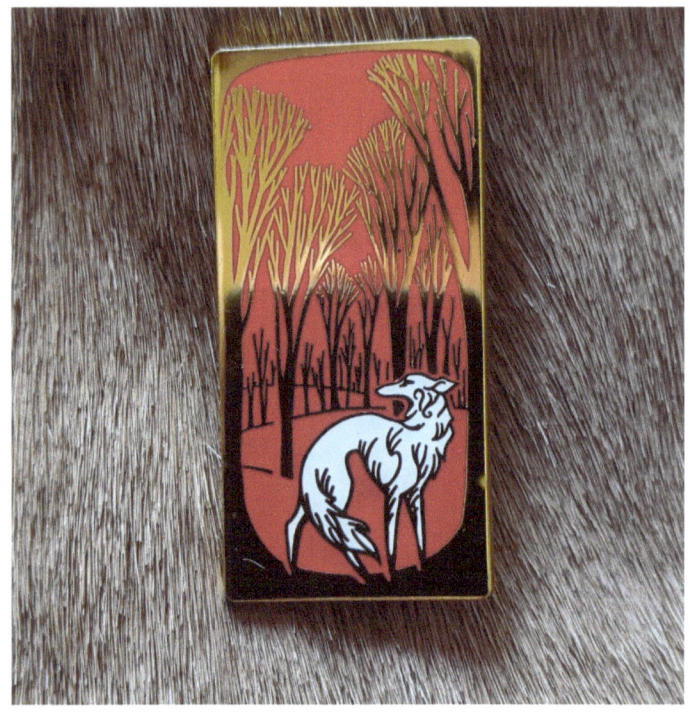

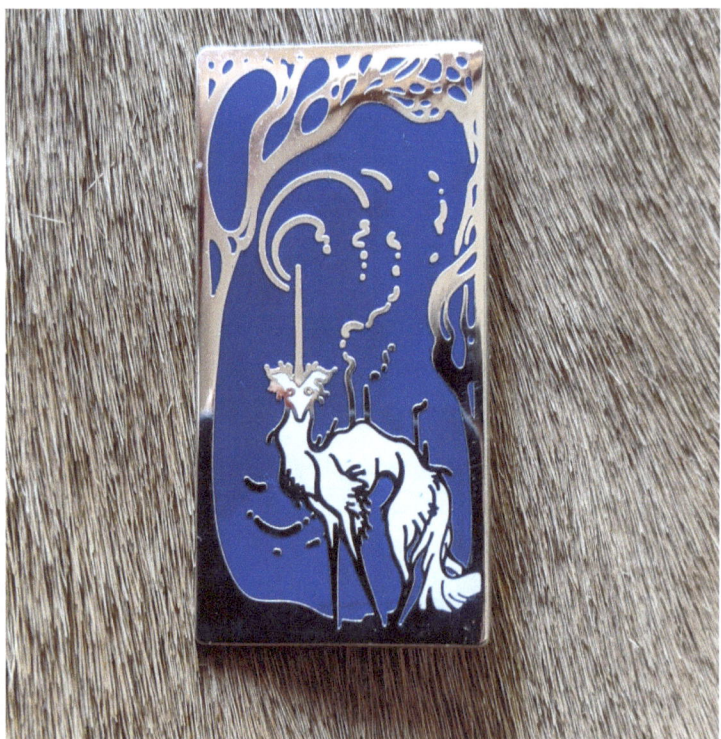

For this series of pins I drew on my eternal love of Art Deco and Art Nouveau, fitting elegant designs within tall, narrow frames, as well as leaning on the iconographic influence of my Silken Saints.

Copper Forest Fae (top left) is evocative of warm and beautiful walks in autumn forests, while Littlest Unicorn (bottom left) is a glimpse of a magical being in a midnight winter forest.

I received so many inquiries for these pins I decided to translate the design into other media including acrylic hangings (right), gold foil cards (below), and metallic vinyl stickers (not shown).

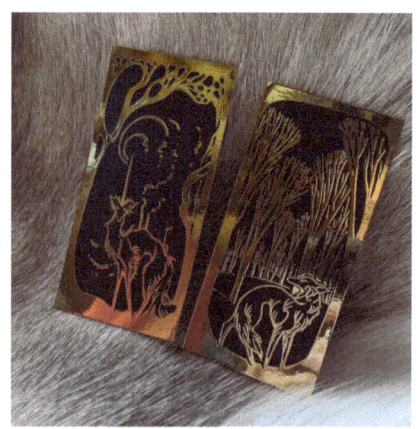

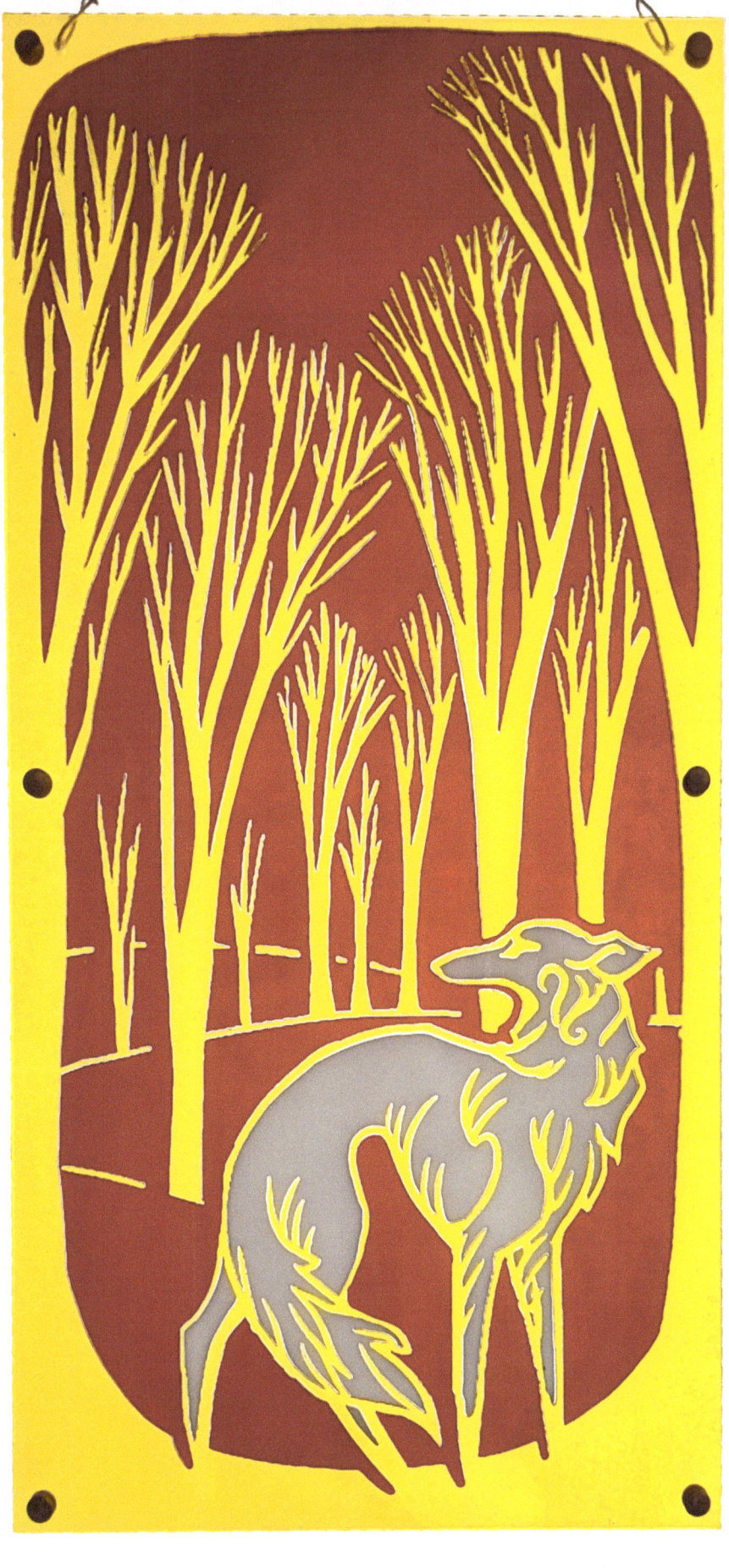

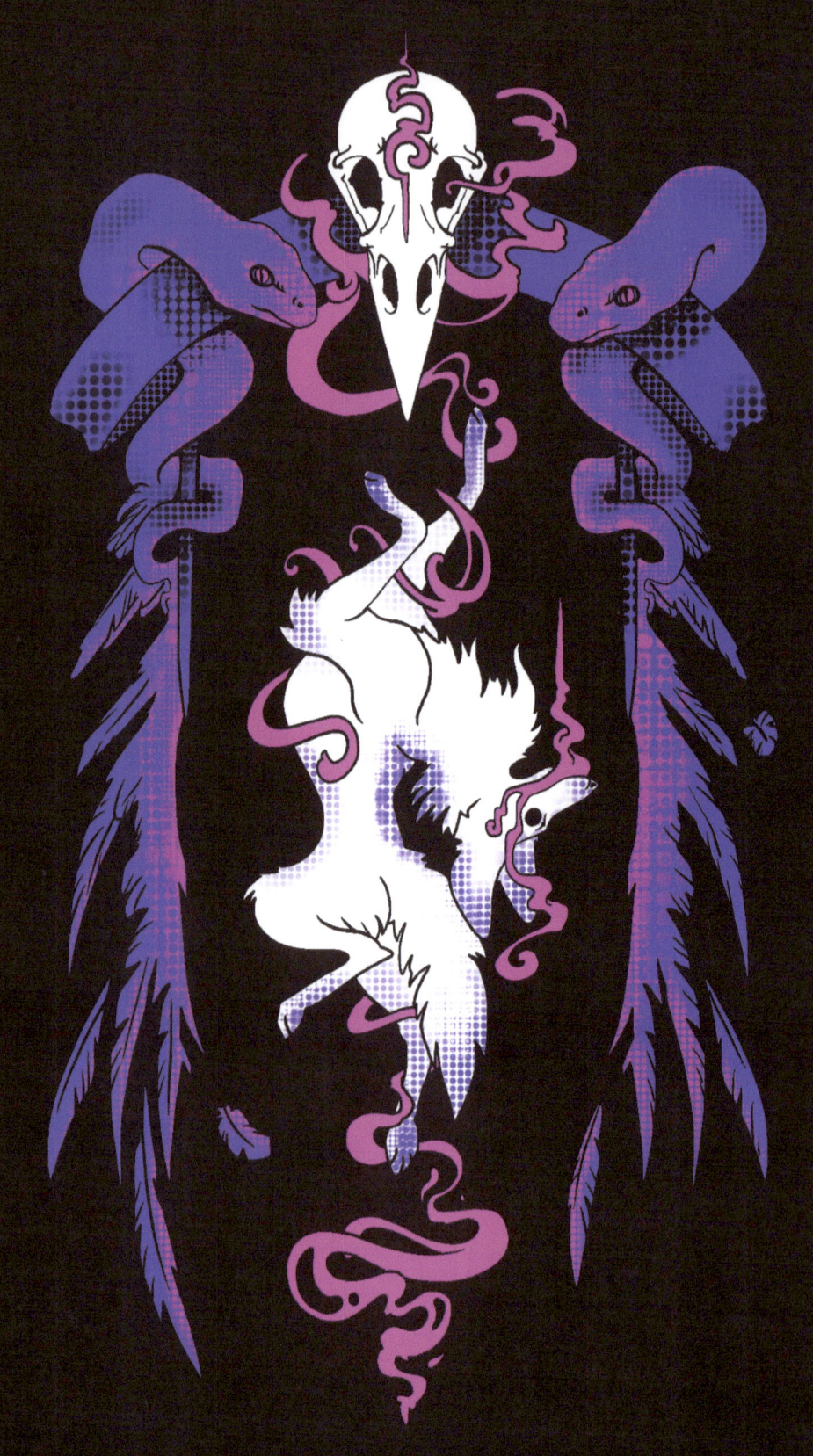

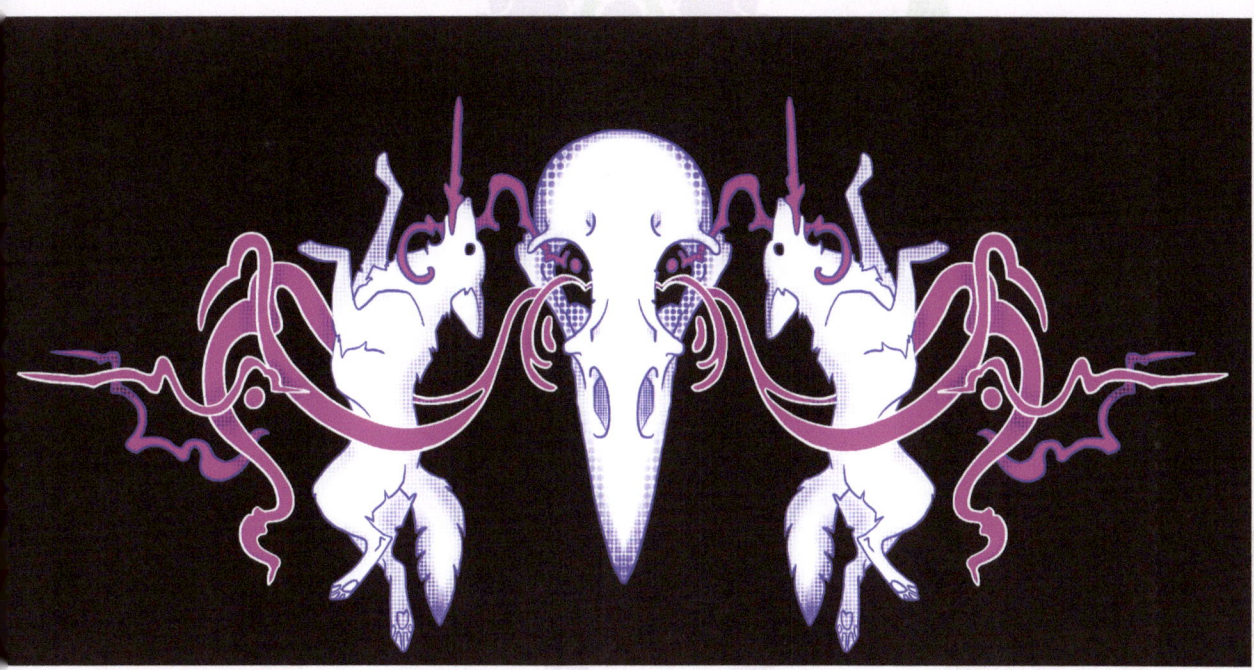

# Spirit Dance

The line between life and death and the cyclical nature of an organisms time on earth has always fascinated me. Growing up surrounded by animals also had me surrounded by death. From accidents to old age or disease, death was present in life. I find the cycle one that should be celebrated instead of feared. The body may decay but it is transmuted into new life, our souls and atoms turning back into the base elements and stardust from which they began.

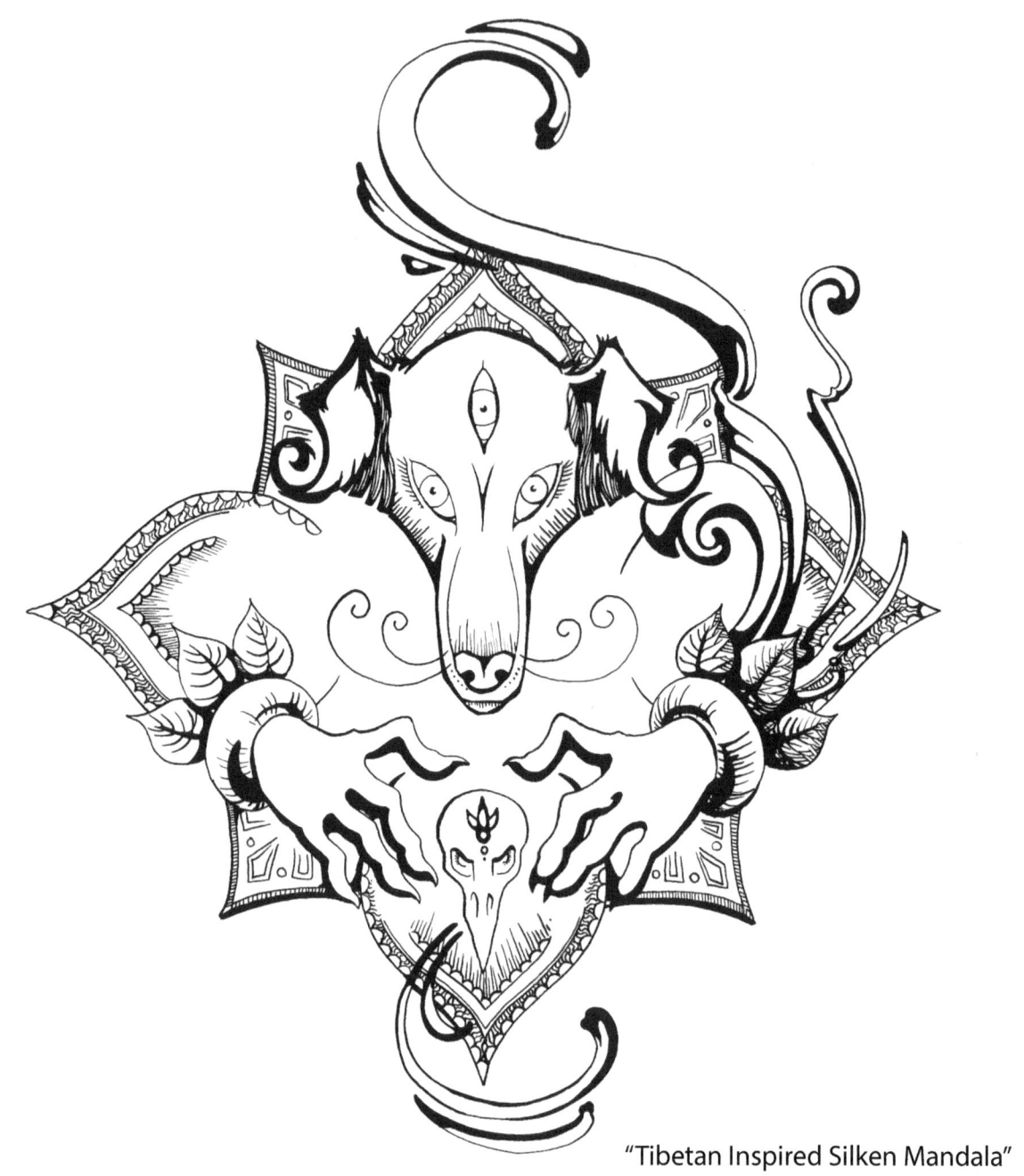

"Tibetan Inspired Silken Mandala"

# Zen in Ink

Sometimes the simplicity of black and white is a haven. There is something incredibly meditative in working in pen and ink or restricting myself to this palette. The results range from elegantly bordered pieces inspired by Tibetan mandalas, to woodcuts art, to simple shadow blocking with smooth lines.

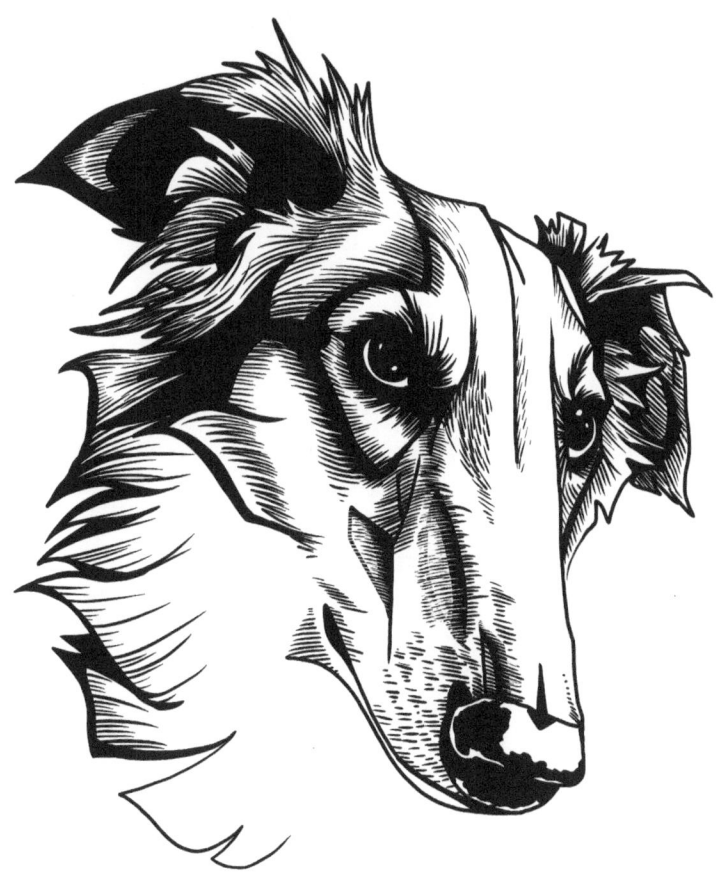

"Woodcut Baku"

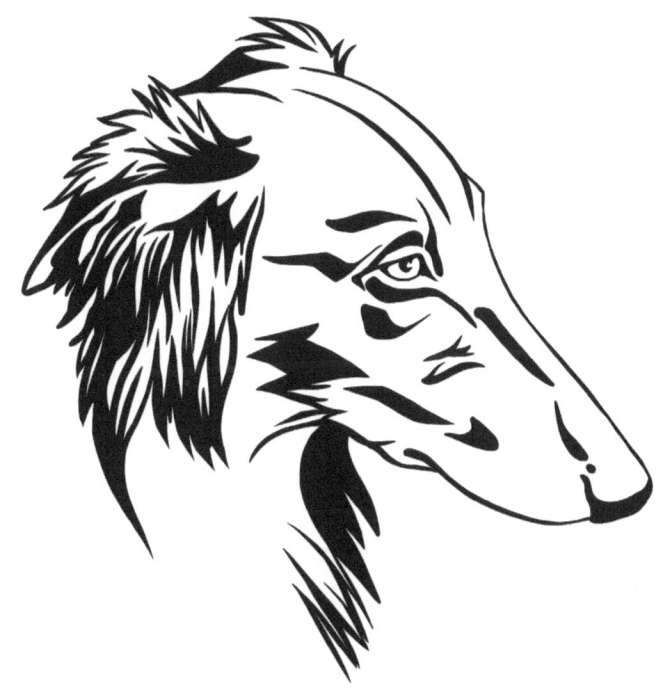

"Archer Portrait"

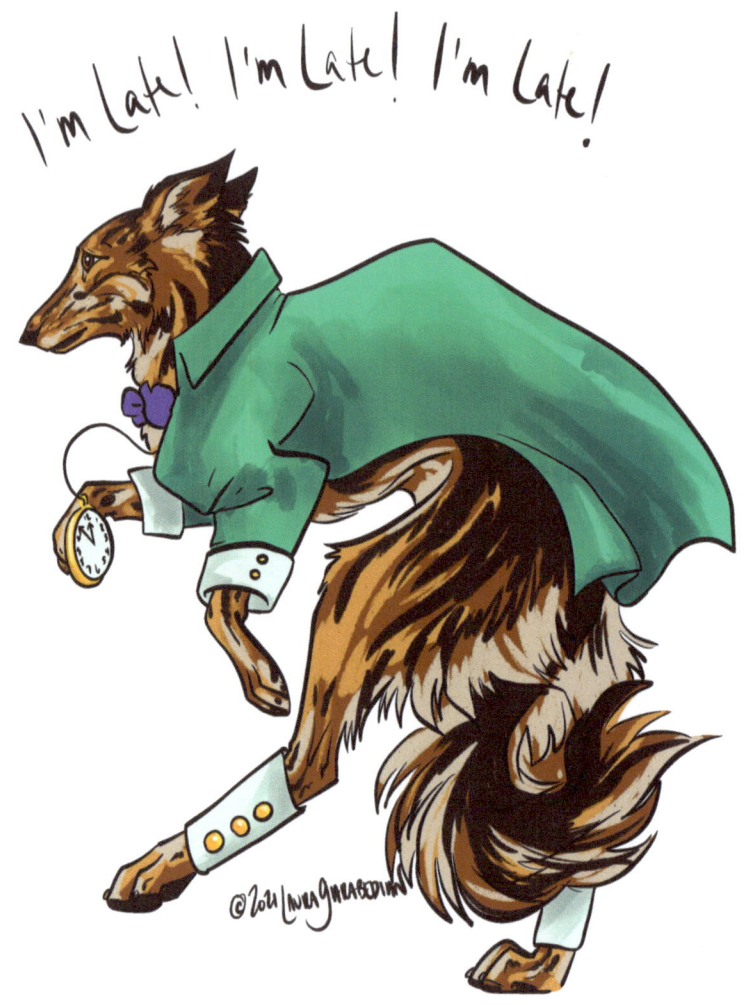

## I'm Late!

I thought it would be fun to see you all off with a smile. As someone who is normally quite punctual or early, this was a fun gift for a friend who is quite the opposite, with her sweet boy pretending to be the White Rabbit.

"Dogs in the Dark Storm Pattern"

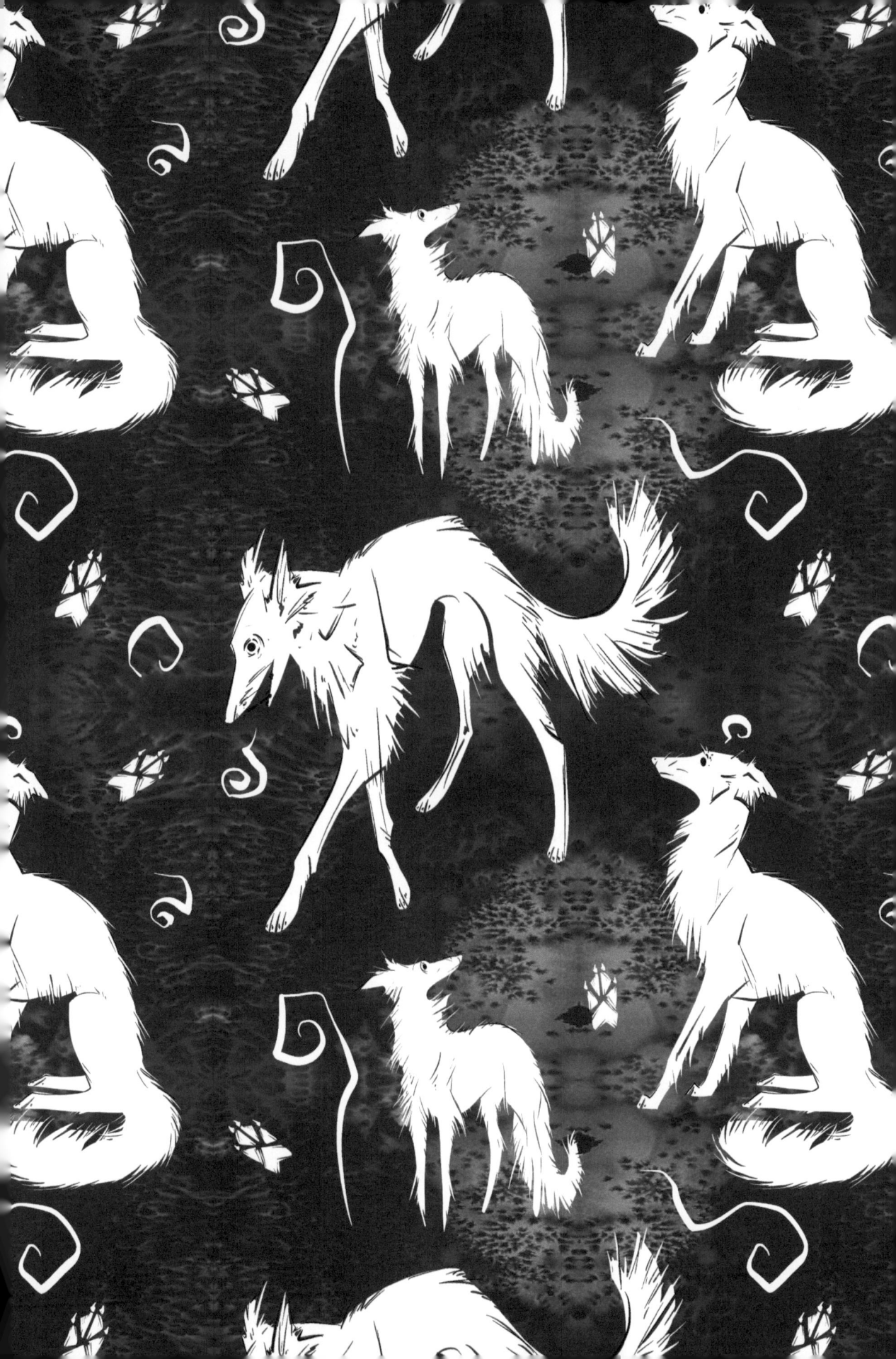

# About the Artist

Photo by Anastasia (Balaa) Korochanskaya

Laura lives in Colorado with her three Silken Windhounds, her Husbeast, and a small flock of chickens. She enjoys traveling whenever possible, and looks forward to adventuring when everyone has their shots. (Sign of the times, this book was made early 2021)

www.FairyTalesWithTails.com

Art@LauraGarabedian.com

www.ingramcontent.com/pod-product-compliance
Lightning Source LLC
Chambersburg PA
CBHW041319180526
45172CB00004B/1153